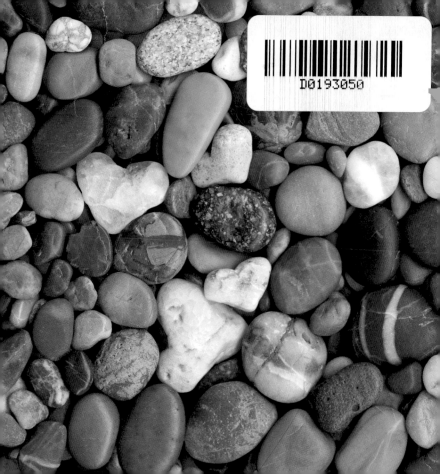

D0193050

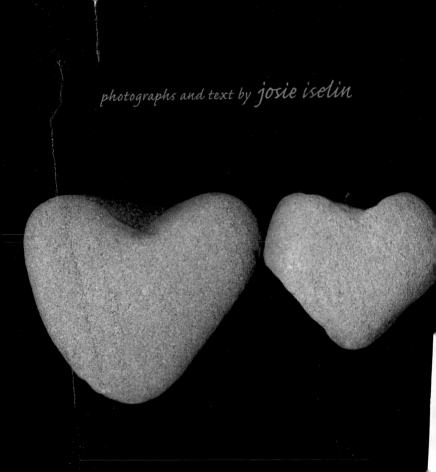

photographs and text by *josie iselin*

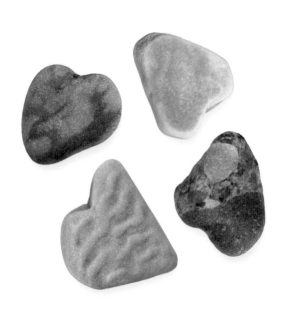

heart stones

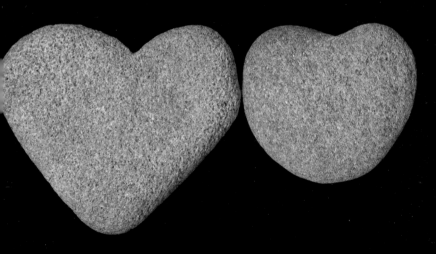

abrams, new york

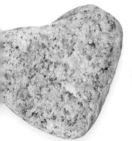

Editor: Eric Himmel
Designer: Darilyn Lowe Carnes
Production Manager: Jules Thomson

Library of Congress Cataloging-in-Publication Data

Iselin, Josie.
 Heart stones / by Josie Iselin.
 p. cm.
 ISBN-13: 978-0-8109-9465-2 (Abrams)
 1. Photography of rocks. 2. Heart in art. I. Title.
 TR732.I85 2007
 779'.9552—dc22 2007030718

HNA ▉▉▉▉▉
harry n. abrams, inc.
a subsidiary of La Martinière Groupe
115 West 18th Street
New York, NY 10011
www.abramsbooks.com

Published in 2007 by Abrams, an imprint of Harry N. Abrams, Inc.
All rights reserved. No portion of this book may be reproduced,
stored in a retrieval system, or transmitted in any form or
by any means, mechanical, electronic, photocopying, recording,
or otherwise, without written permission from the publisher.

Printed and bound in China
10 9 8 7 6 5 4 3 2 1

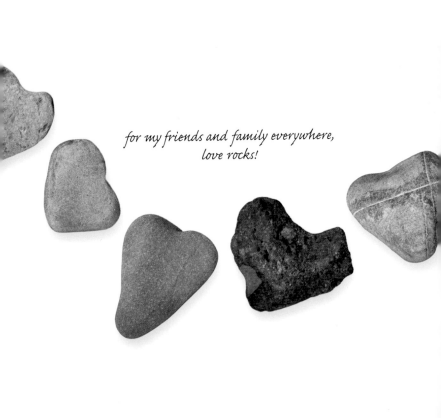

*for my friends and family everywhere,
love rocks!*

introduction

I was at the beach recently, on a foggy day. The tide was right and the assortment of stones was infinite. The slow meander, with eyes down, scanning for pebbles—deciding which to leave and which to pick up— was a meditative and calming time. But when my eye fell upon a heart-shaped stone, bejeweled with white flecks of fossil, my pulse quickened. This was a keeper.

The heart stone is a lovely vessel. When you take it home and set it on your windowsill or dresser, its presence buoys you up. When you give it to a friend or lover, you give what you have filled it with: strength, love, and confidence. It is an intimate gift; the connections are powerful.

I am often confounded by the power of the heart stone's message. Heart stones, after all, are not rare or precious in the typical sense—a good scour of a beach with any stones at all will usually turn up one or two. But heart stones, lifted from their obscurity, with all their cracks and blemishes, lopsided and imperfect, are simply the best. Two or more together are a family; they are shared love, they are the support we give and get from each other.

What is it about this shape that transforms a stone into something so much more? It is a shape we have become amazingly adept at recognizing, and yet it has no clear origin. Perhaps first inspired by the curves of the human body, the heart is the quintessential and universal symbol expressing the abstractions of love. A heart stone, moreover, is intriguing in itself, being an absolutely natural thing whose meaning is a purely human construct. Its shape arises, without artifice, from the geologic weaknesses and variations within it; over time it abrades and dissolves silently into the valentine that speaks to us so clearly.

The heart stones here were collected over many years by me and a network of friends—friends I have known forever and friends I have yet to meet from among the fraternity of stone lovers who share an abiding respect for the Earth and her wonders. These friends packed up their treasures and trusted the mail, giving me the joy of arriving home to boxes of heart stones on my doorstep. But these stones are just a smattering of the affection waiting to be found out there in the world. Love is where you find it. Happy hunting.

love

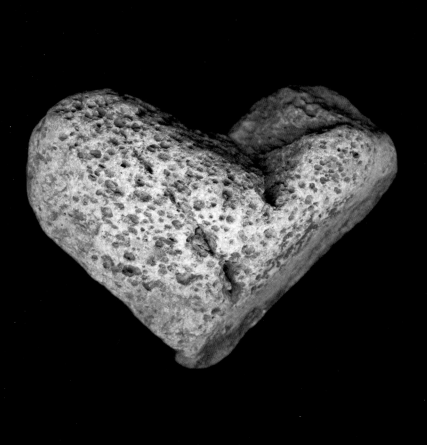

strength

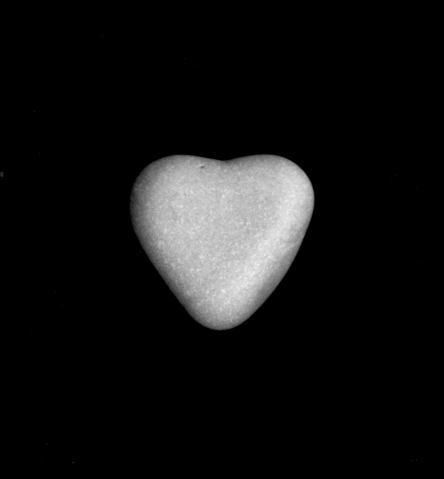

romance

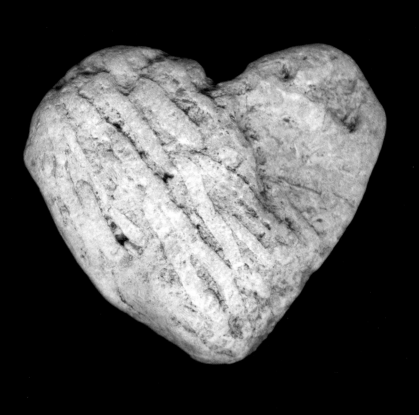

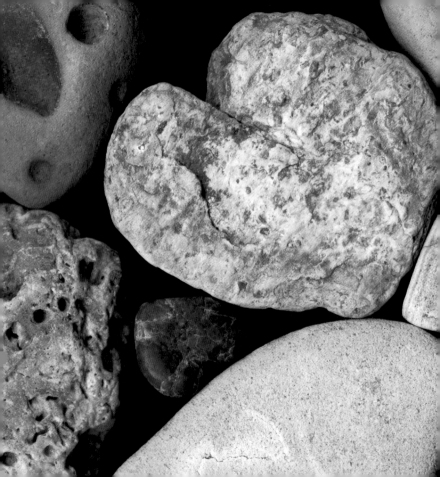

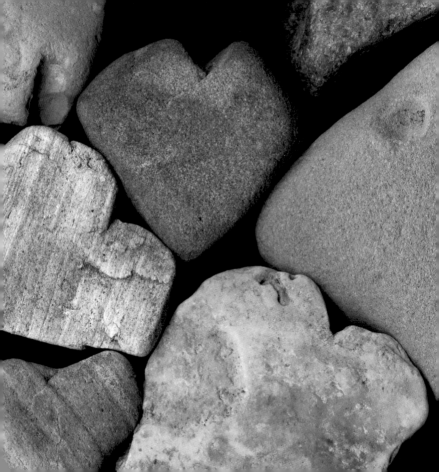

imagination

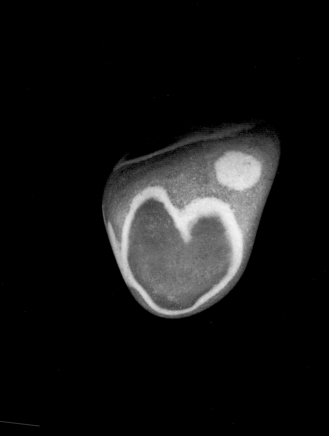

memory

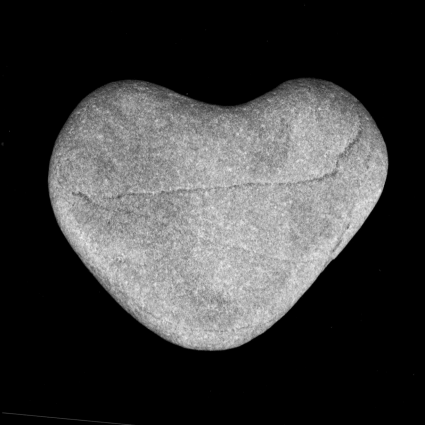

mystery

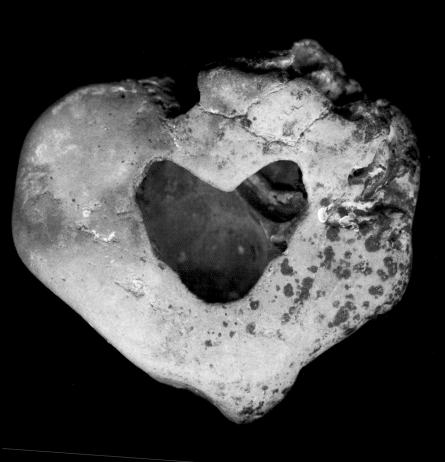

gesture

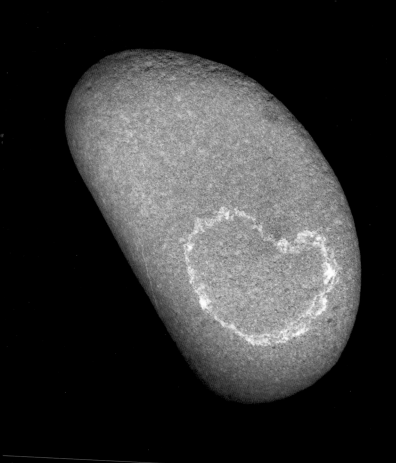

care

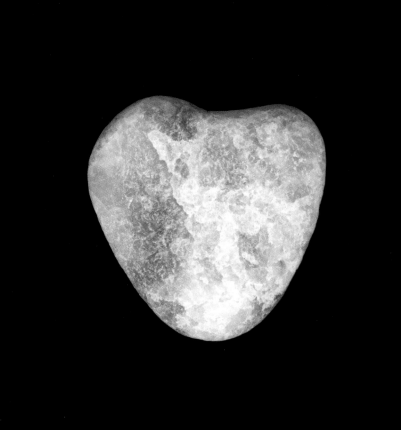

intrigue

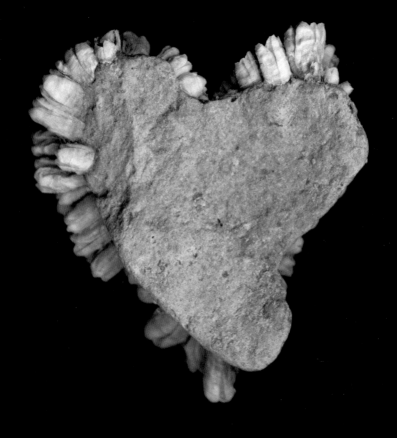

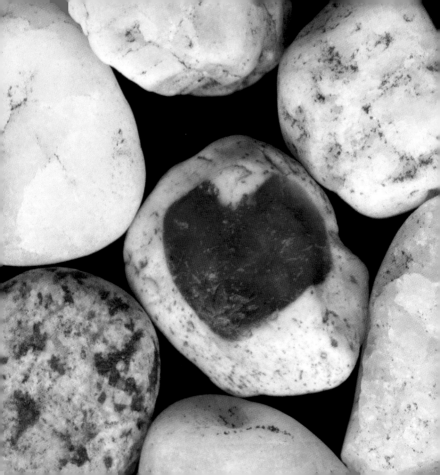

honor

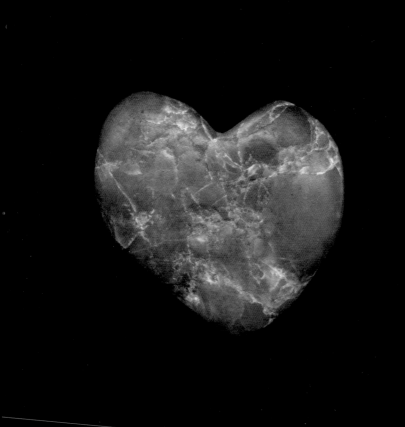

presence

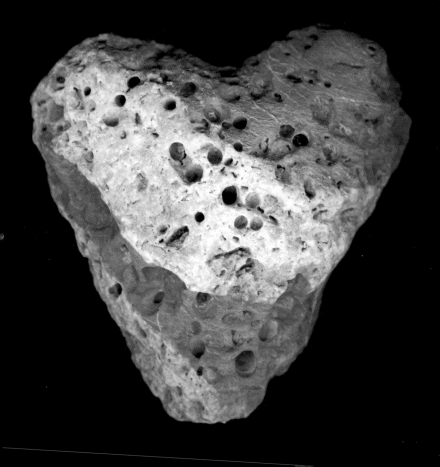

bedrock

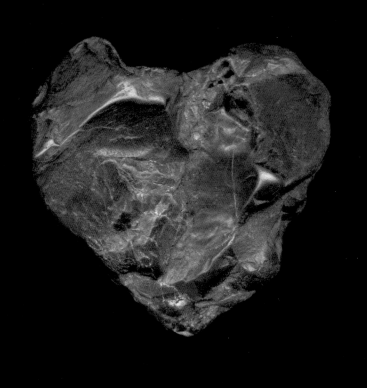

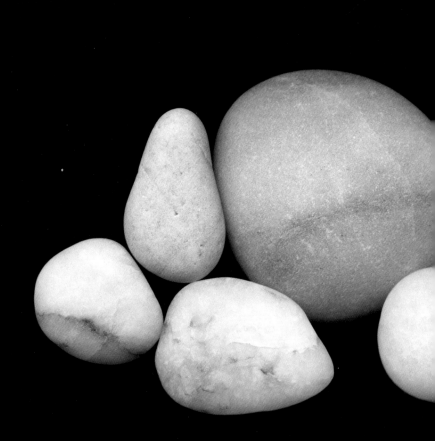

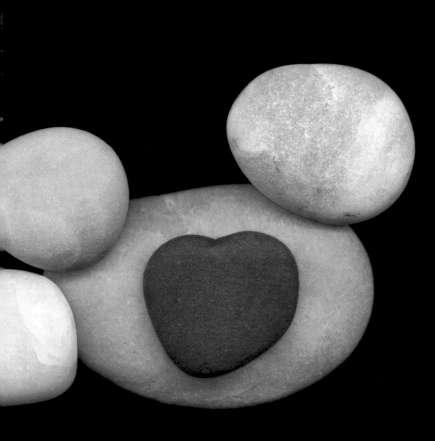

puzzle

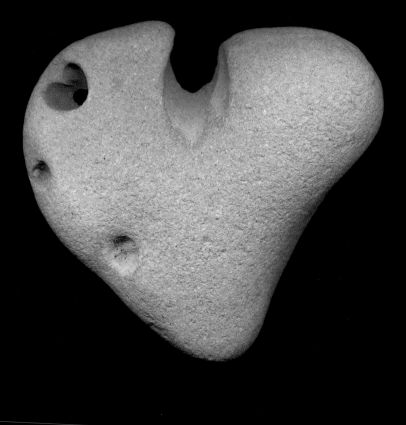

partner

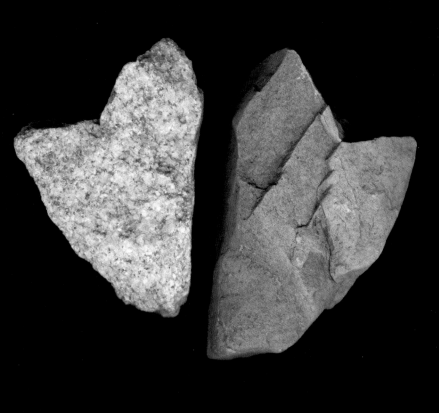

reliance

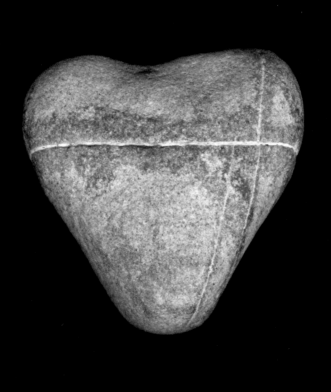

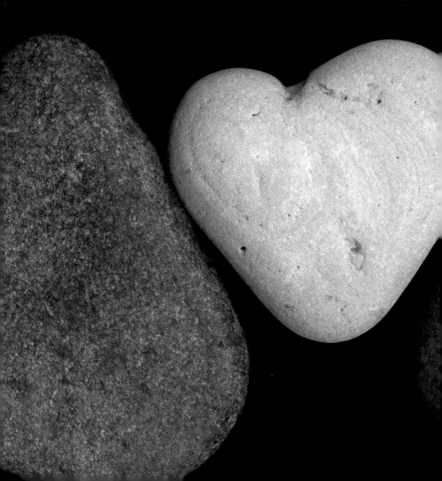

history

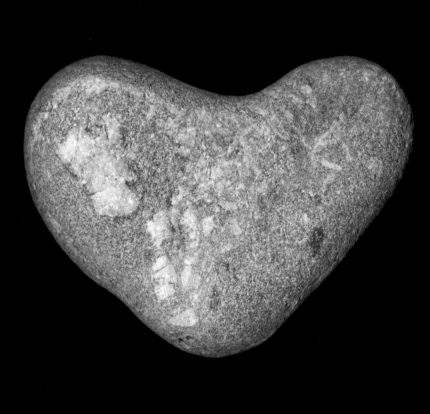

comfort

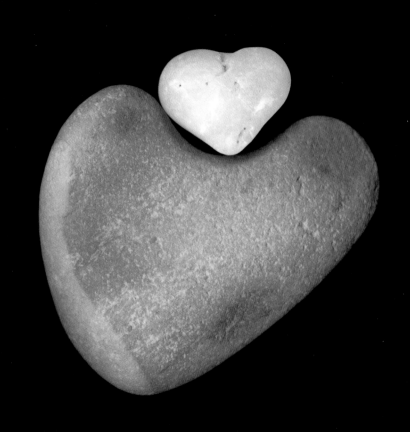

iconoclast

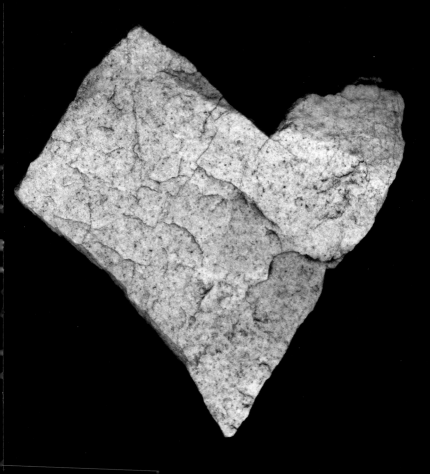

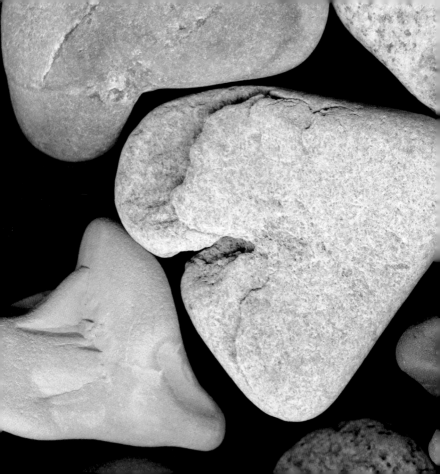

esteem

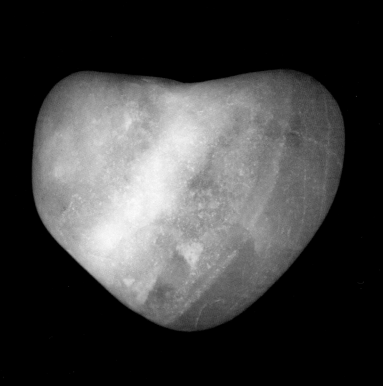

sustenance

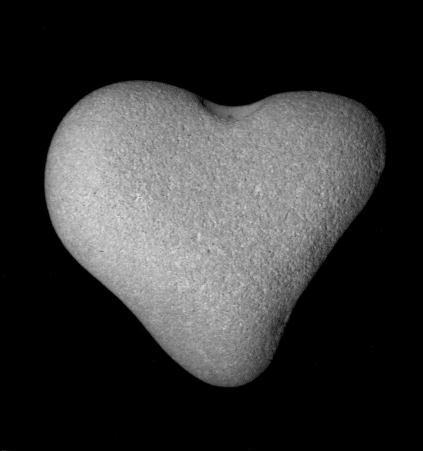

delight

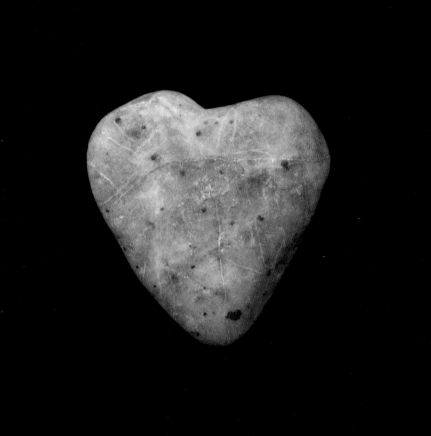

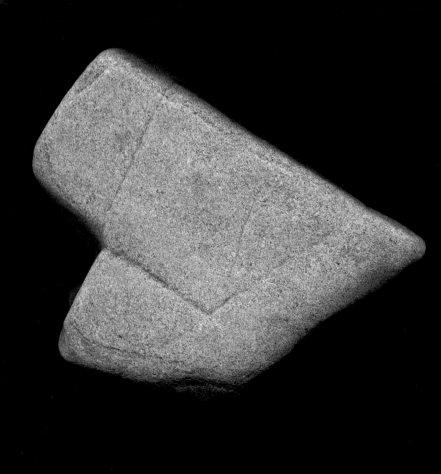

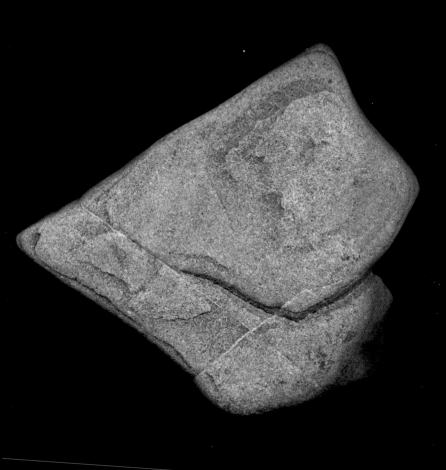

home

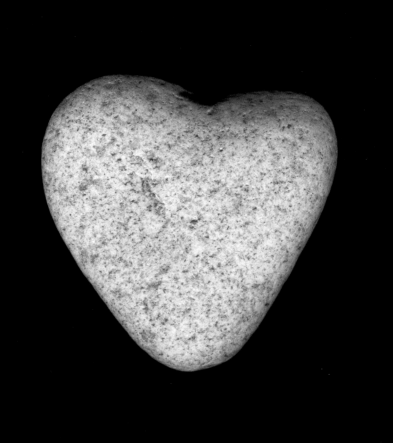

adventure

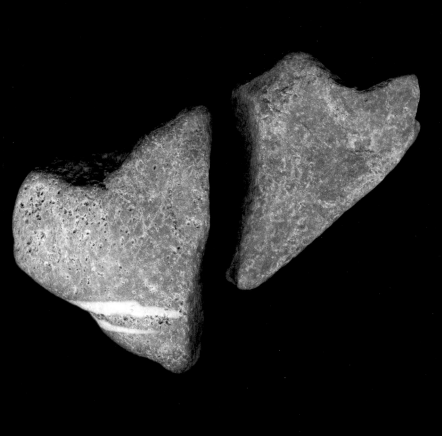

sensation

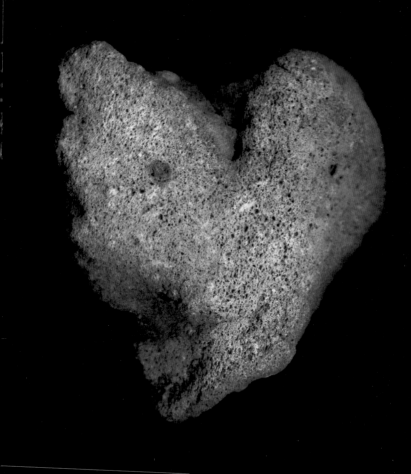

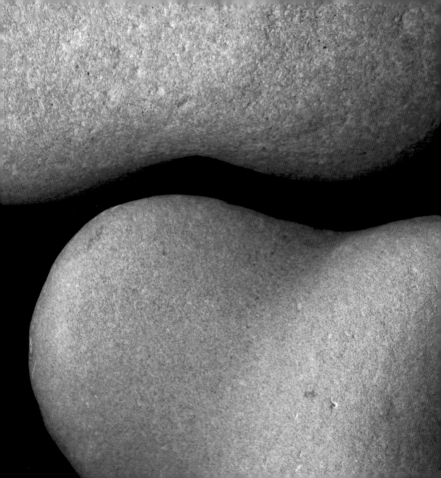

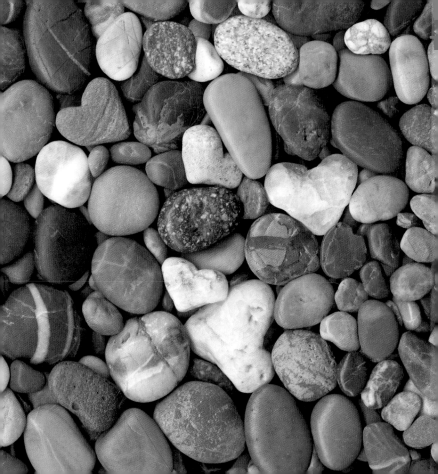

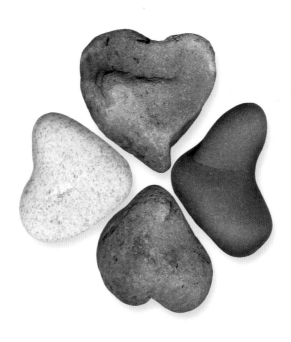

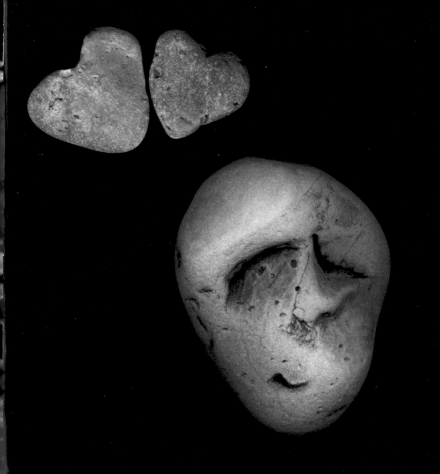

acknowledgments

Once again, as with my previous books, I am deeply indebted to all those who lent me their treasures for this project. It is a leap of faith to hand over such irreplaceable objects of love.

My deepest thanks go to Mary Haas, Justine Marosi, Darcy Lee, Alison Matoon, Caio Driver, Bari Ness, Pamela Gien, Keylan Skaggs, John Rafkin, Moss Brenner-Bryant, Co Rogan, Paige Hart, Tony Roderick, Bonnie Maxwell, Ellie and Elizabeth Corbus, Miranda Finestone, Cathy and Lucy Iselin, and my children, Eliza, Deedee and Andrew. I must also thank Caroline Herter, and Margaret Carruthers for her wonderful way with words about stones. Working with Eric Himmel and Darilyn Carnes at Abrams has been, as always, a joy. Lastly, I must thank my husband, Ken Pearce, who deserves more heart stones than I have to give.

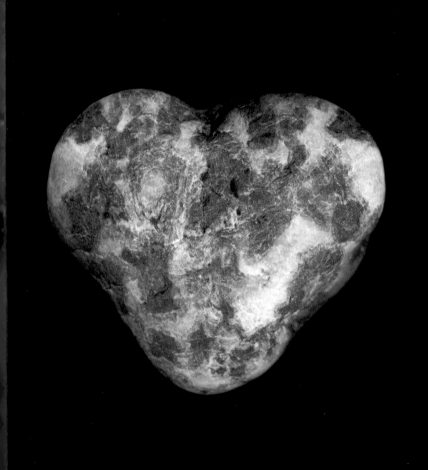

joy

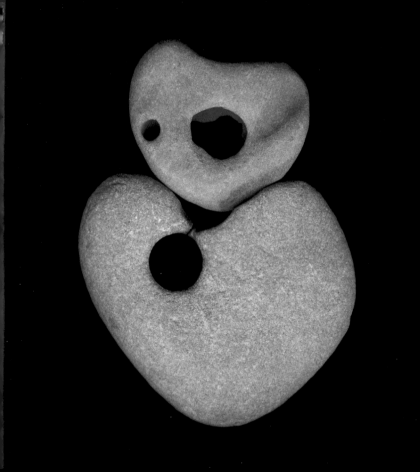

sincerity

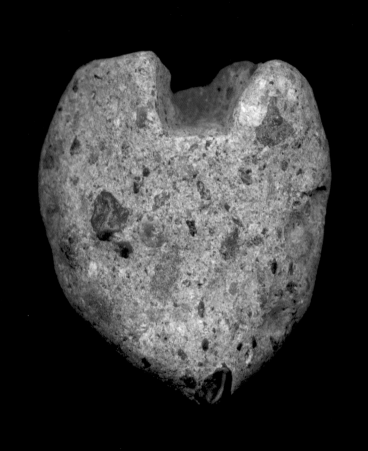

complexity

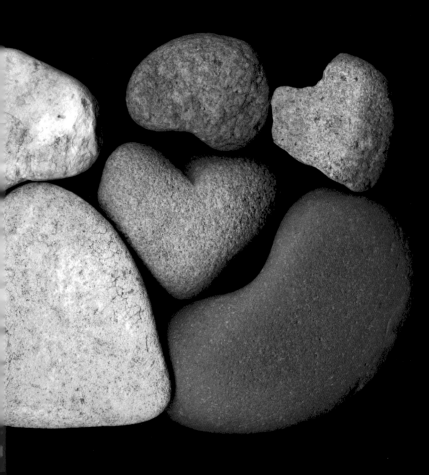

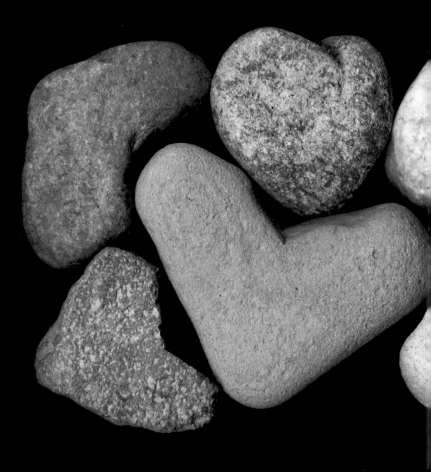

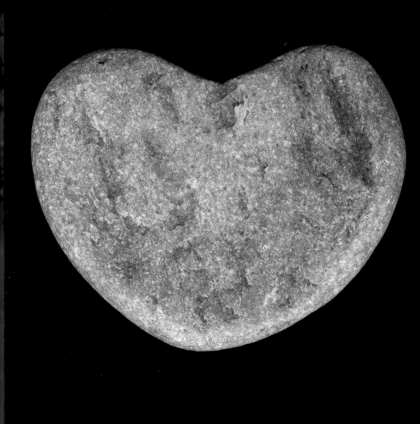

hope

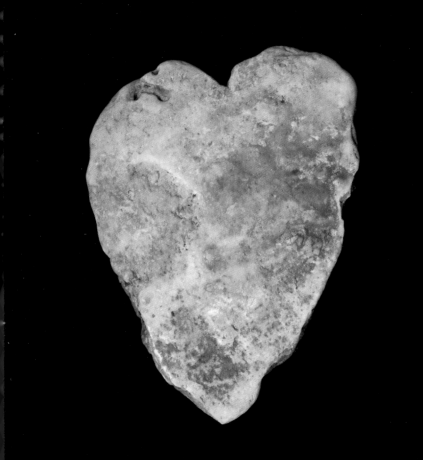

friendship

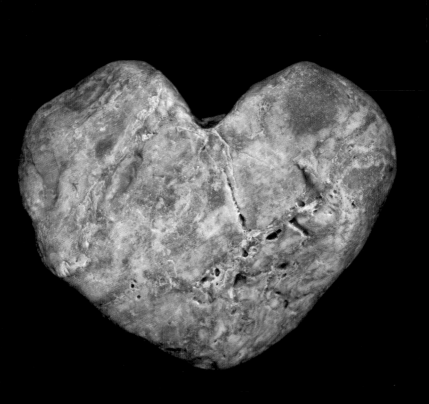

wonder

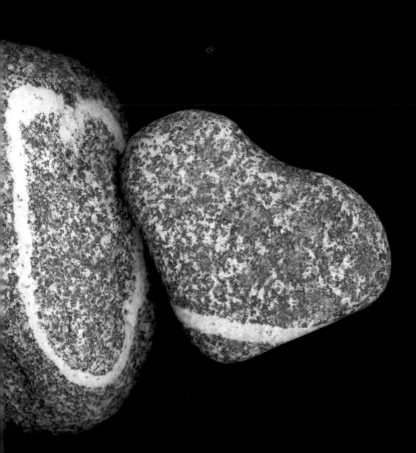

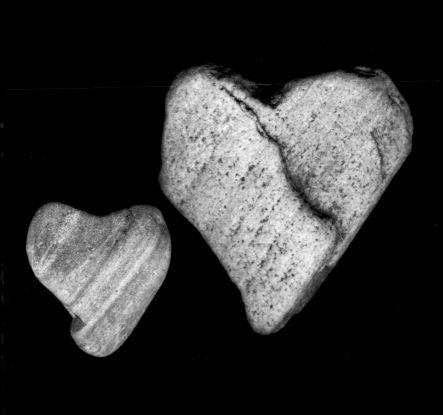

congruence

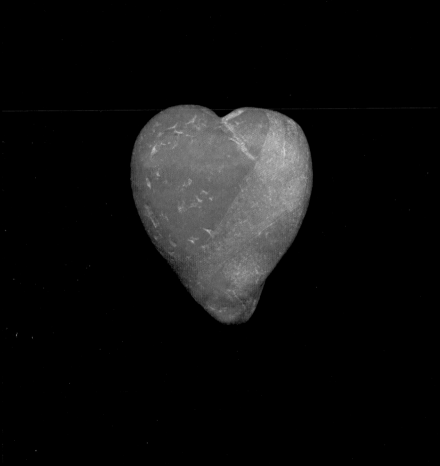

solitude

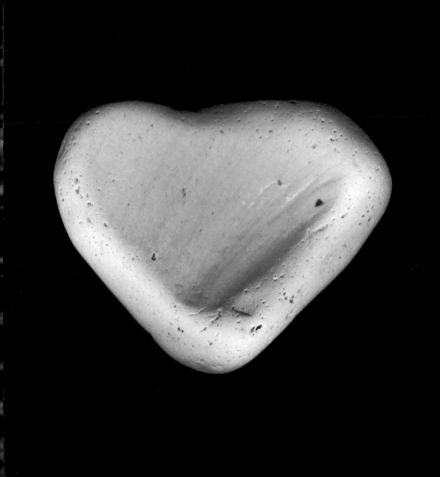

passion

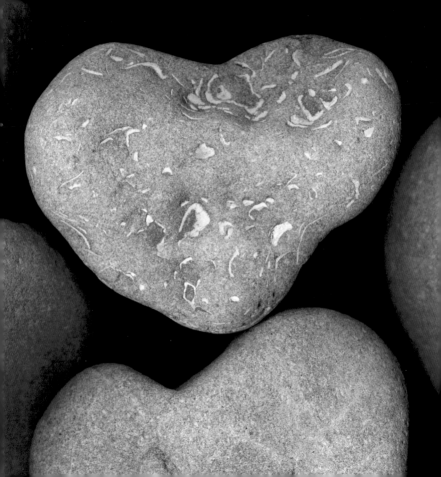